Rustic Bridge

This subject captures the moment when, while out walking in the woods, you happen on a tranquil scene, interrupted only by the sound of birds and rippling water. Then you whip out your paints and dash off a masterpiece! Seriously, this scene has a strong focal point and the composition leads you through the picture and off into the distance.

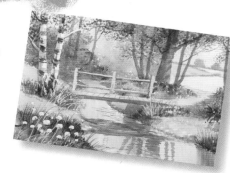

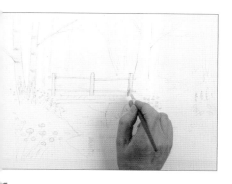

1 Transfer the scene from the tracing and mask the edges with masking tape. Paint masking fluid on the trees, flowers, bridge and bridge reflection.

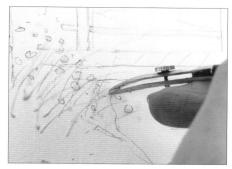

2 Use the ruling pen and masking fluid to mask the grasses and the stalks of the cow parsley.

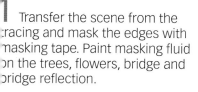

3 Use the golden leaf brush to paint a wash of cobalt blue in the sky area.

4 Scrunch up a piece of kitchen paper and use it to lift out colour from the wet wash to create clouds.

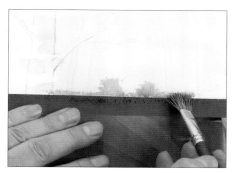

5 Mask off the horizon with a magazine page and use the foliage brush and diluted midnight green to stipple on a hedge and trees.

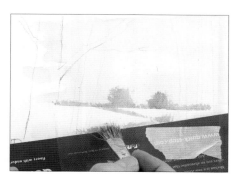

6 Use the magazine page at different angles to create more hedgerows coming forwards.

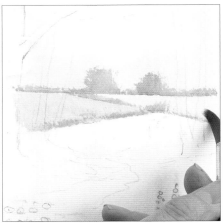

7 Paint the fields with pale washes of midnight green on the left and sunlit green on the right.

8 Paint the next field with a thin wash of raw sienna.

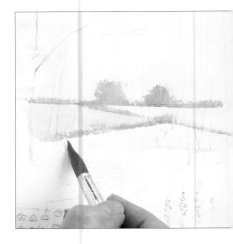

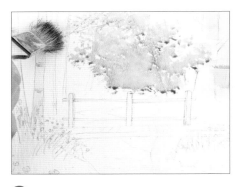

9 Take the golden leaf brush and a mix of cobalt blue and sunlit green and stipple in the foliage, leaving a gap in the middle. Then stipple cadmium yellow and fill the gap.

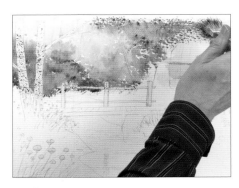

10 Stipple country olive over the masked silver birch trees and on the right.

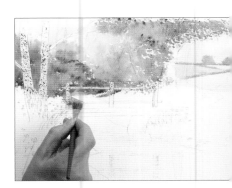

11 Change to the wizard brush and paint country olive down to the water's edge.

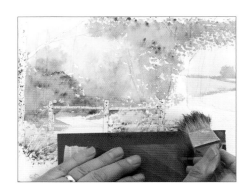

12 Mask off the footbridge with a magazine page and use the golden leaf brush with raw sienna and sunlit green to stipple foliage above it.

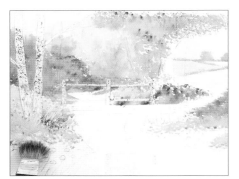

13 Stipple with sunlit green on the grassy banks of the stream.

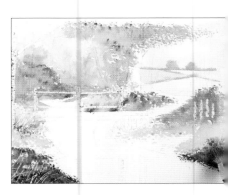

14 Paint midnight green mixed with country olive over the foreground on the right and left of the stream. Allow to dry.

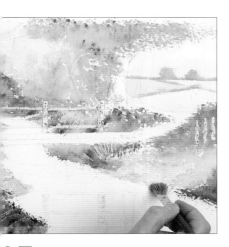

15 Use the foliage brush with raw sienna to paint the sunlit areas on either side of the stream, working wet on dry.

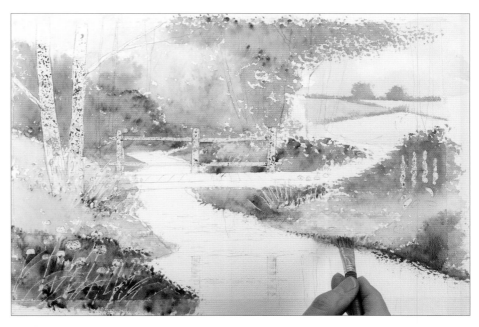

16 Drop in burnt sienna wet in wet along the water's edge.

17 Now that the background is dry, stipple on a dry mix of country olive with the golden leaf brush to build up the distant foliage.

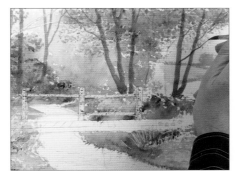

18 Use the medium detail brush and burnt umber mixed with country olive to paint the distant trees.

19 Paint the large tree trunk on the right with a mix of raw sienna and sunlit green.

20 Paint the shaded side of the tree wet in wet using burnt umber and country olive. Add texture.

21 Paint the footpath up to the bridge with the wizard brush and raw sienna.

22 Add burnt umber to the mix to paint the footbridge itself.

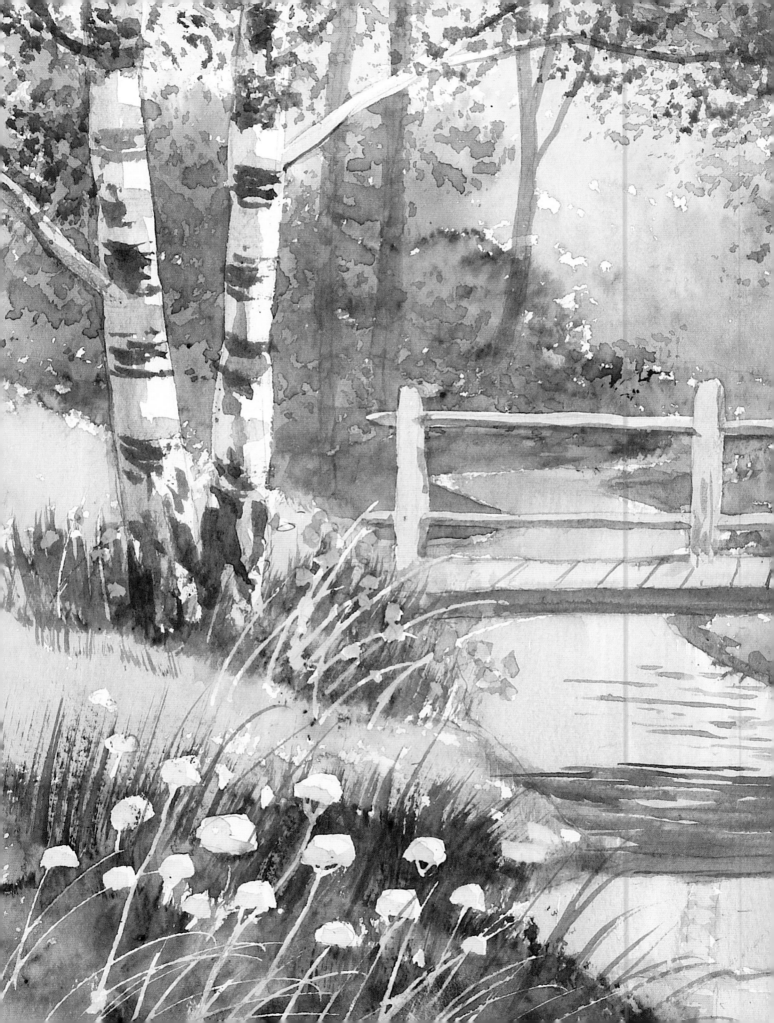

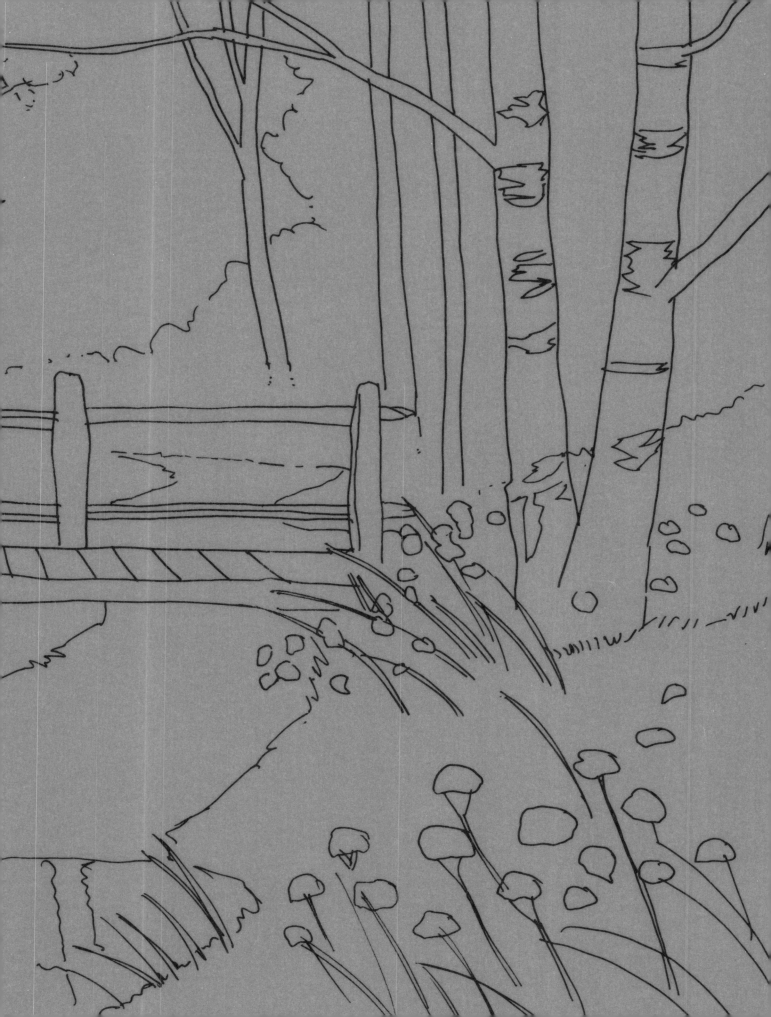

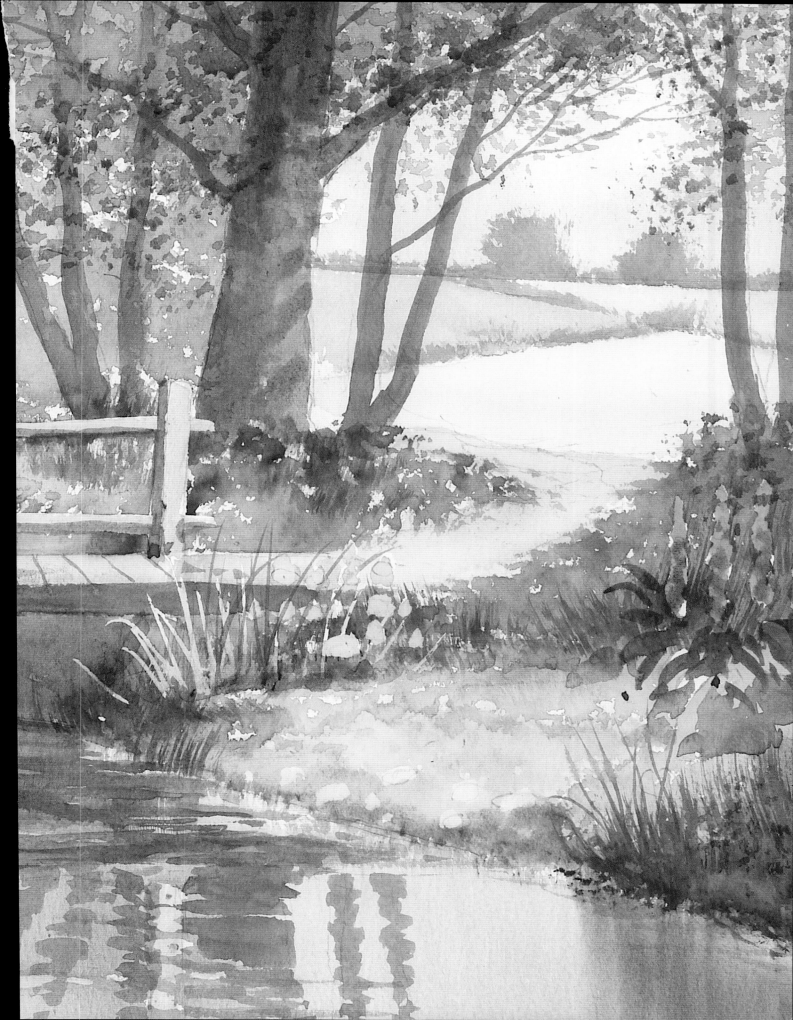

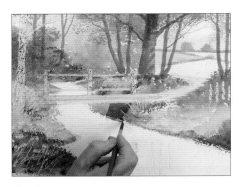

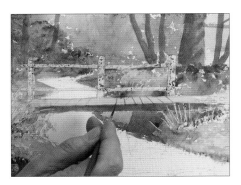

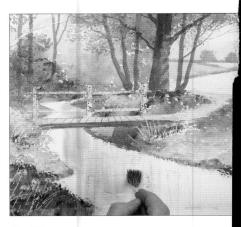

23 Use the medium detail brush to paint country olive under the bridge. Allow it to dry.

24 Paint the front of the footbridge with a mix of burnt umber and country olive, then change to the half-rigger to paint the planking.

25 Wet the stream area with clean water and then pick up cobalt blue and country olive on the wizard brush and drag it downwards.

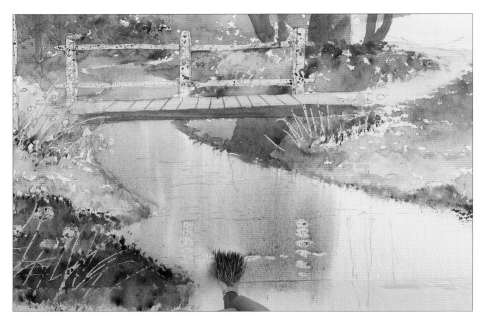

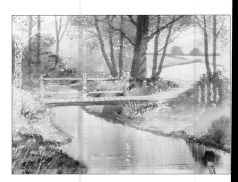

26 Make a greener mix of country olive with a touch of cobalt blue and drag it down the water area wet in wet.

27 Add cobalt blue and then midnight green on the right, dragging down the colours wet in wet.

28 Take the 19mm (¾in) flat brush and country olive and paint the reflection of the bridge with a side to side motion.

29 Make a light mix of cobalt blue and country olive and paint the smaller ripples.

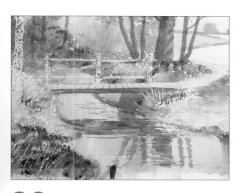

30 Paint reflections of trees using the medium detail brush and country olive with burnt umber.

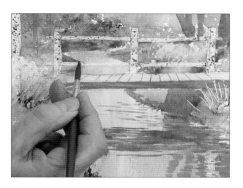

31 Use country olive to darken the stream bank, highlighting the contrast with the water.

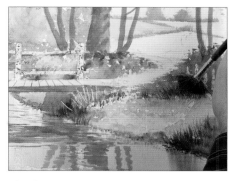

32 Change to the fan gogh and create areas of darkness under the silver birch and behind the foreground flowers by flicking up grasses with country olive.

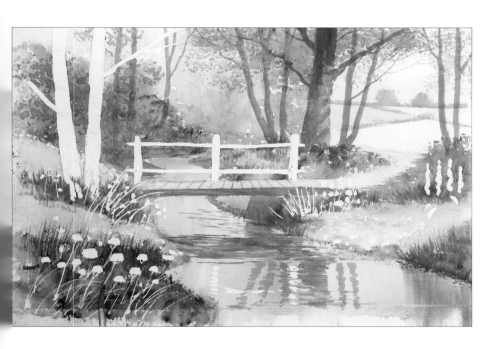

33 Remove the masking fluid by rubbing with clean fingers. Paint the grasses and stems with sunlit green and the medium detail brush.

34 Paint the bridge rails with a thin mix of raw sienna and burnt umber.

35 Paint the reflection of the bridge with the same colour.

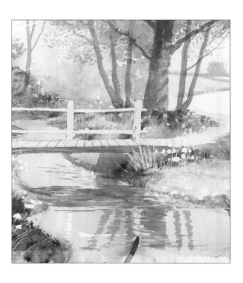

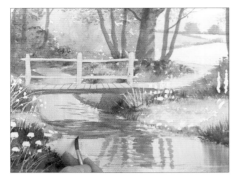

36 Use burnt umber and country olive for the reflection of the front of the bridge.

37 Paint the left-hand side of the silver birch with a mix of cobalt blue and a little burnt umber. Make horizontal brush strokes to suggest the patchy bark.

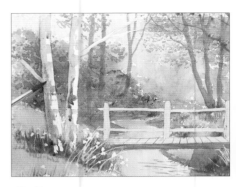

38 While the paint is wet, drip in burnt umber. Allow to dry.

39 Mix ultramarine and burnt umber. Hold the half-rigger almost flat and drag it sideways wet on dry to produce the ragged markings on the bark.

40 Paint the fine branches with the same brush and colour.

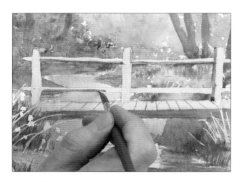

41 Mix burnt umber and country olive and use the medium detail brush to shade the bridge posts and rails.

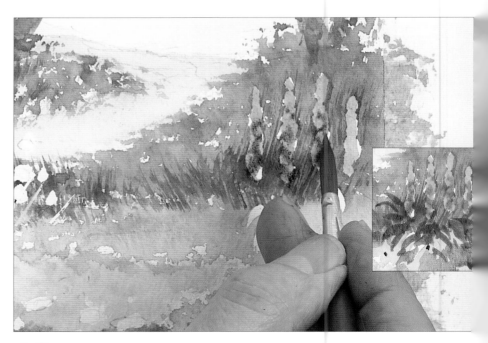

42 Paint the foxgloves with a permanent rose wash, then while this is wet, drop in a touch of cobalt blue and permanent rose. Paint the leaves with midnight green.